Cats
IN HATS

Cats
IN HATS

KAT SCRATCHING

THOMAS DUNNE BOOKS
ST. MARTIN'S GRIFFIN ❧ NEW YORK

THOMAS DUNNE BOOKS
An imprint of St. Martin's Griffin

For information, address St. Martin's Press, 175 Fifth Avenue,
New York, N.Y. 10010.

www.thomasdunnebooks.com
www.stmartins.com

Library of Congress Cataloging-in-Publication Data
on file at the Library of Congress

ISBN: 978-1-250-11189-0 (hardcover)
ISBN: 978-1-250-11190-6 (e-book)

Editorial and design by
Amber Books Ltd
74–77 White Lion Street
London N1 9PF
United Kingdom
www.amberbooks.co.uk

Project Editor: Sarah Uttridge
Designer: Rick Fawcett
Picture Research: Terry Forshaw

Printed in China

Our books may be purchased in bulk for promotional, educational, or business use.
Please contact your local bookseller or the Macmillan Corporate and Premium Sales Department
at 1-800-221-7945, extension 5442, or by e-mail at MacmillanSpecialMarkets@macmillan.com.

First U.S. Edition: February 2017
10 9 8 7 6 5 4 3 2 1

PICTURE CREDITS

Depositphotos: 10 (Vitaly Titov & Maria Sidelnikova), 12 (Barbara Helgason), 14 (Ulf2010), 16 (Willeecole), 20 (Katrina Elena), 22 (Plus69), 26 (Ermolaev Alexandr Alexandrovich), 28 (FotoJagodka), 56 (Hanna Maria), 60 (Stephanie Zieber), 62 (Valyiskaya Svetlana), 64 (Vvvita), 66 (Hanna Darzy), 68 (Vvvita), 70 (Tobkatrina), 72 (Funny Cats), 76 (Funny Cats),
Depositphotos/Chris Brignell: 6, 18, 32-54 all, 58
Dreamstime: 74 (Viatcheslav), 78 (Linn Currie), 80 (Fotosmile), 82 (Linn Currie), 84 (Lilun), 86 (Chris Brignell), 94 (Amm 78)
Fotolia: 8 (Chris Brignell), 24 (Dora Zett), 30 (Vvvita), 88 (Kalmatsuy Tatyana), 90 (Chris Brignell), 92 (Chris Brignell), 96 (Andrey Kuzmin)

Contents

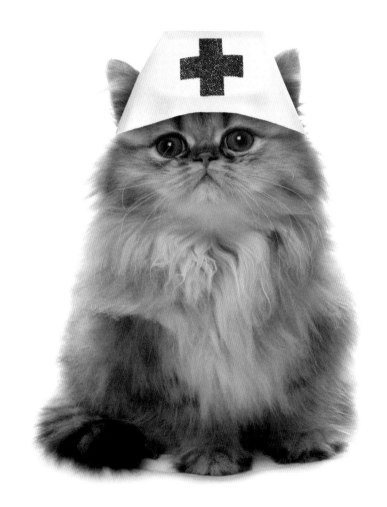

Feeling *Pawly?*

"It's time for your CAT scan."

Hat Fact: Largely replaced by scrub hats today, nurses' caps became common in the mid-19th century. Florence Nightingale helped popularize them by insisting that the nurses who worked with her during the Crimean War (1853–56) wore a uniform and cap.

Cat Fact: More than 300 years of breeding have made the Persian cat a great deal stockier than when it first arrived in Europe from Persia in the 17th century.

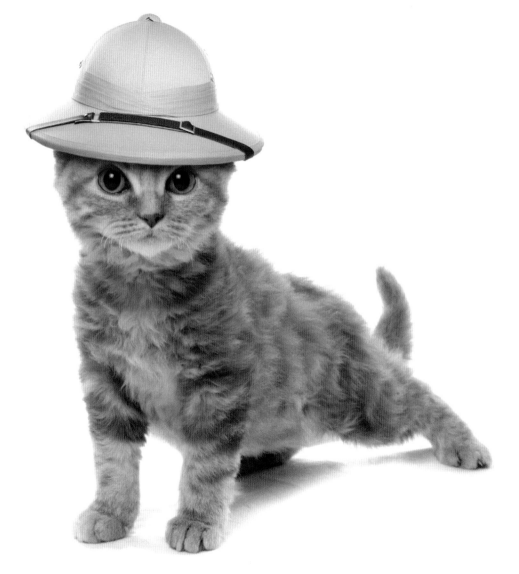

Pithy Cat

"I'm an intrepid explorer—I've been to every single yard in the neighborhood."

Hat Fact: Pith helmets became popular among Europeans in tropical colonies during the 19th century. They were first made from plant pith and covered in cloth. While they were later made from cork and cloth, the original name remained.

Cat Fact: The domestic shorthair is a cat of mixed ancestry and not one particular breed. These cats can be any color.

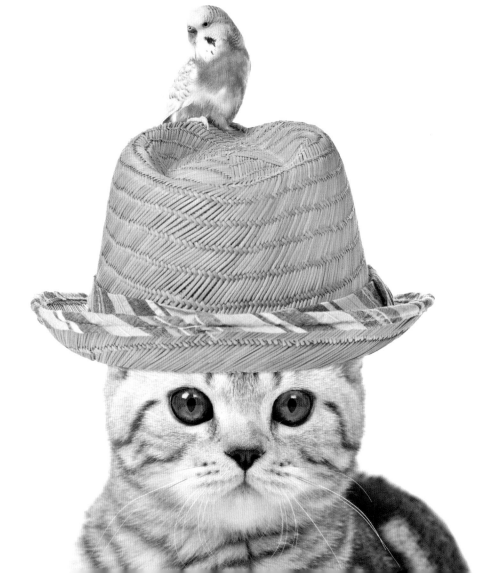

Parrot Fashion

"I'm warning you. I may not look like the cat that ate the canary, but one more chirp and you'll be feathers."

Hat Fact: A straw trilby. The hat's name comes from the stage play of George du Maurier's 1894 novel *Trilby*. A hat of this style was worn in the first London production of the play, and came to be called "a trilby hat."

Cat Fact: A pedigreed cat breed, the American shorthair is believed to be descended from the cats that were brought over on ships with the first European settlers to North America.

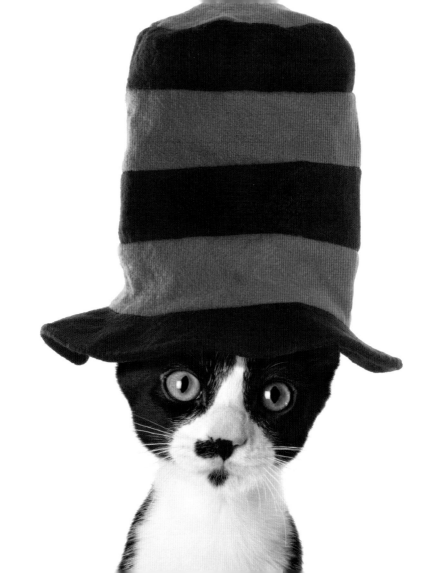

The Original Cat in the Hat

"I do not like having famous looks and I do not like
Dr. Seuss's books."

Hat Fact: In the Dr. Seuss book *The Cat in the Hat*, the Cat
wears a red and white striped hat. Dr. Seuss wrote the book
in 1957 in an effort to create a more entertaining book for
younger readers than those available at the time.

Cat Fact: In British English, domestic shorthairs are often
affectionately called "moggies."

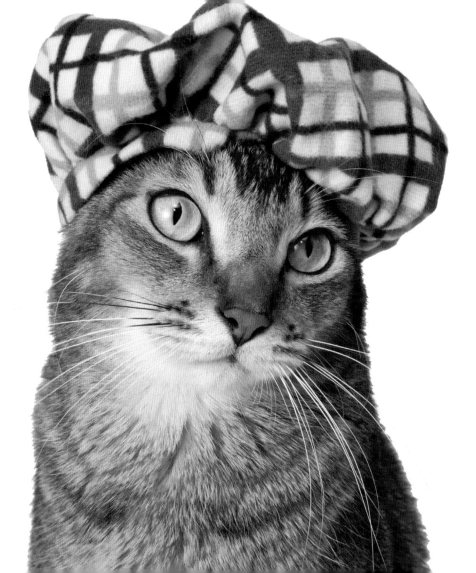

The Loch Ness Moggy

"I enjoy a *cat*nip of whisky."

Hat Fact: A hat loosely based on the tam o' shanter, which is named after the hero of Robert Burns's 1790 poem. In it, Tam is drunkenly riding home one night when he stumbles across a witches' coven and is pursued. He and his horse Meg escape, but the witches pull off Meg's tail. The name was given to the military cap worn by Scottish soldiers during World War I.

Cat Fact: On an Abyssinian cat, each hair has a light base with three or four bands of additional color growing darker toward the tip, creating the breed's distinctive flecked effect.

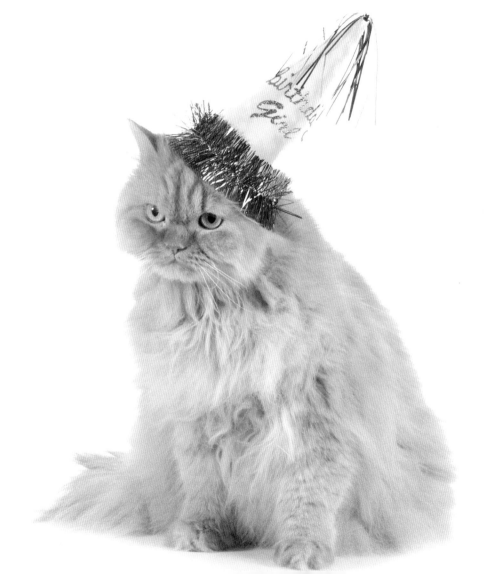

*Purr*thday Puss

"It's my party, and I'll purr if I want to."

Hat Fact: The traditional party hat is similar to the dunce's hat, worn by poorly performing or misbehaving schoolchildren.

Cat Fact: Because Persian cats have such thick, long coats, they must be groomed regularly.

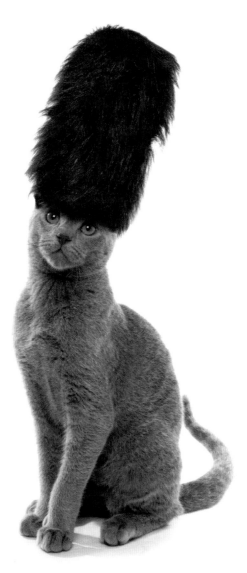

Un*bear*ably Itchy

"Calm down, it's a fake fur."

Hat Fact: Today, bearskins are worn with ceremonial military uniforms, but in the 18th and 19th centuries these tall hats added height to grenadiers on the European battlefield and parade ground. The guardsmen at Buckingham Palace in London, England, wear hats that are 18 inches tall.

Cat Fact: The Russian blue is a short-haired, blue-gray cat, although their coats can range from black to silver. They usually have emerald green eyes. Like the Chartreux cat, it has a thick, soft, double coat.

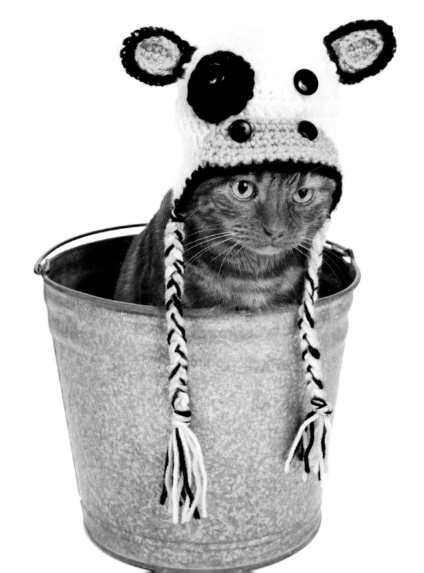

Are You Kitten Me?

"This is not what *I* call a bucket list."

Hat Fact: What do you get if you cross a sheep, a cow, and a pig? Yes, a woolen hat with a cow's face and pigtails.

Cat Fact: Domestic shorthairs are also referred to as house cats, alley cats, and tabby cats.

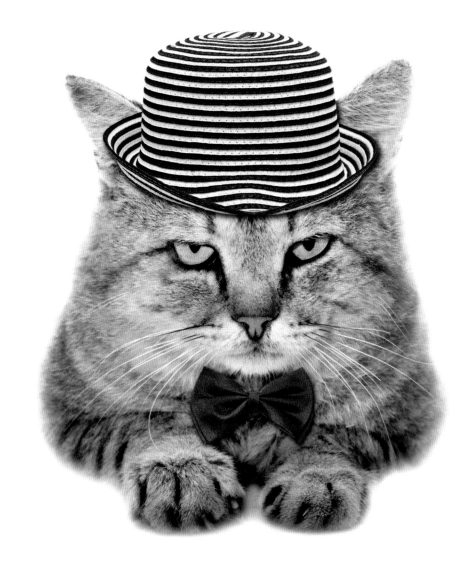

Jazz Cats Waller

"This smart bow tie elegantly disguises my flea collar, don't you think?"

Hat Fact: You've probably noticed that this hat is striped. In contrast, pixie-bobs and bobcats have freckled patterns on their fur.

Cat Fact: Legend claims that pixie-bobs are a result of breeding a domestic cat with a wild bobcat. In fact, they are a purely domestic cat.

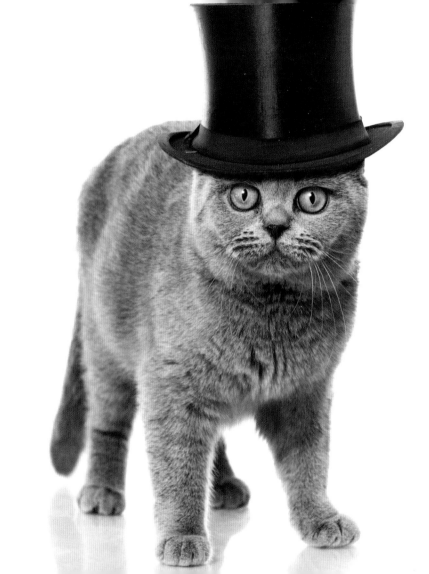

Top Cat

"There's no chance of me pulling a rabbit out of this. I'm just going to eat it where it is."

Hat Fact: Abraham Lincoln chose to stand out from the crowd by wearing high top hats, even though he was 6 feet 4 inches tall without one.

Cat Fact: Chartreux cats are quiet, meow rarely, and can even be mute. They are intelligent. Some have learned to open screen-door latches and switch radios on and off.

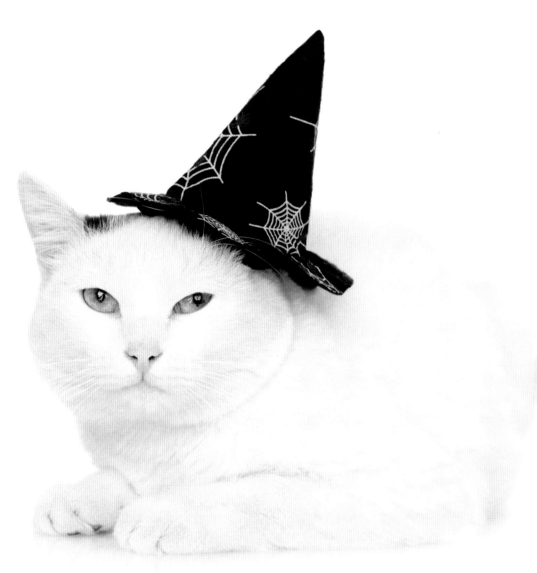

Cat Out of Hell

"Being a cat, I just can't help looking disdainful, but the wizard took offense and magicked away my left ear.

Hat Fact: It wasn't until the 1720s that illustrations in English books began to show witches wearing pointed hats. Quite why isn't clear, but after that the pointed hat look caught on.

Cat Fact: Domestic shorthairs look different around the world. In Southeast Asia, they resemble Siamese cats, while in Europe and North America, they have thicker coats and heavier builds.

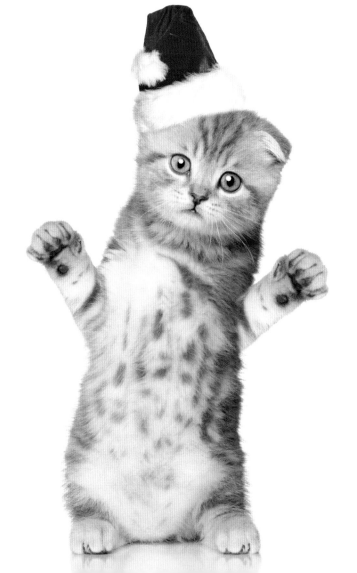

Cat on a Cold, Snowy Roof

"OK, you caught me. But I was only delivering presents."

Hat Fact: Illustrations of Santa Claus have, over the centuries, included ones of him wearing a scarlet coat. But Coca-Cola's Christmas advertising campaigns, begun in 1931, showing a rotund, cheery Santa dressed in red and white, certainly helped popularize what's now the traditional Santa look.

Cat Fact: Scottish folds have a genetic mutation affecting their cartilage, which is most easily seen in their forward-folding ears.

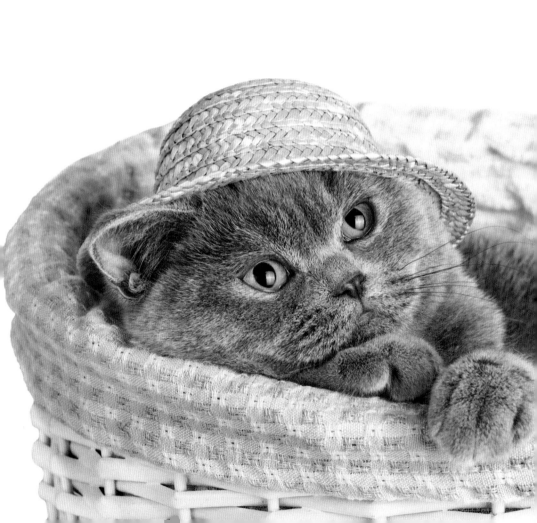

Basket Case

"They say that curiosity killed the cat, so I'm taking things very easy."

Hat Fact: It's highly unlikely that your cat will eat a straw hat.

Cat Fact: A pedigreed version of the British domestic cat, the shorthair is usually a "British blue," with blue-gray fur and copper eyes. There are also tabby and colorpoint variants.

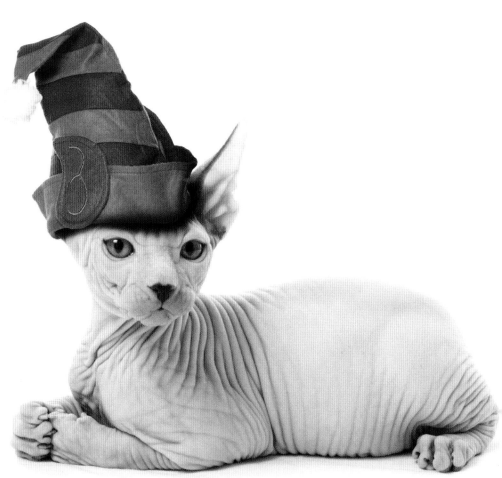

Something the Cat Dragged in

"What would I like for Christmas? Antiwrinkle cream."

Hat Fact: In "Twas the Night Before Christmas," Santa himself is described as a "right jolly old elf," while in the Christmas 1863 edition of the monthly magazine *Godey's Lady's Book*, the front cover showed Santa surrounded by toys and elves.

Cat Fact: Sphynx cats, first bred in the 1960s, aren't as hairless as they might appear; they have fine hairs on their body. They are among the more extroverted and doglike of cat breeds.

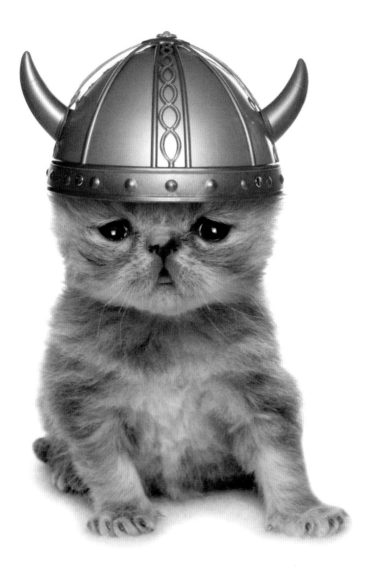

The Cat That Beat Columbus

Yes, the Vikings—and their ships' cats—were the first Europeans in North America. And it makes their hair stand on end to hear that part of it is now called Labrador.

Hat Fact: Contrary to popular myth, the Vikings didn't wear horned helmets.

Cat Fact: The ancestor of the exotic shorthair is the long-haired Persian.

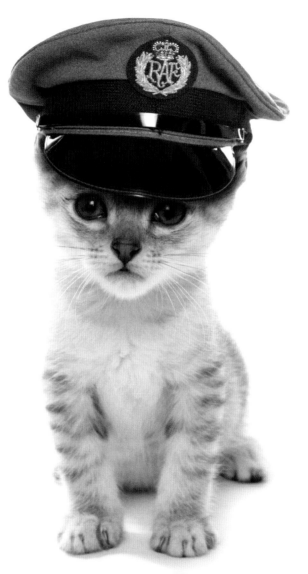

Peaked Cat

"I know, I know, don't you just love a kitten in uniform?"

Hat Fact: The peaked cap originated with working-class men in northern Europe in the early 19th century, but its lightweight practicality soon saw it rising through the ranks. This hat was worn by members of the Royal Air Force.

Cat Fact: Beginning in 1976, the Australian Mist was bred as a mix between Burmese, Abyssinian, and miscellaneous, domestic, short-haired cats.

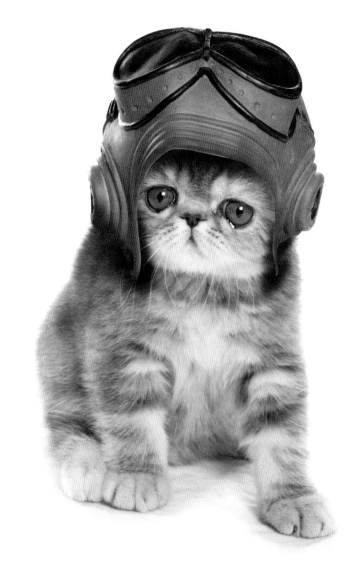

Fighting Like Cats

"These dogfights are a real game of cat-and-mouse."

Hat Fact: Although flying caps and goggles were no longer necessary once closed cockpits were introduced in the 1920s, they remained in use until after World War II.

Cat Fact: Developed from the short-haired Persian, the exotic shorthair is largely capable of looking after its own fur, unlike long-haired Persians.

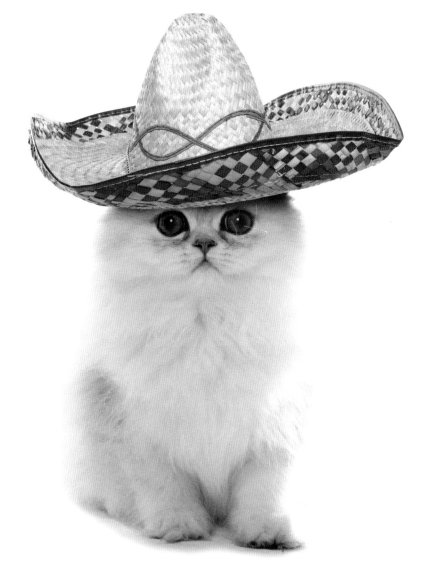

Tortilla Cat

"My friend went on vacation to Mexico, and all I got was this lousy chinchilla."

Hat Fact: Sombrero, which is Spanish for "hat" and means "shadower," is a traditional Mexican sun hat.

Cat Fact: Chinchillas, also known as silver Persian cats, are quiet, gentle, loyal, and intelligent.

41

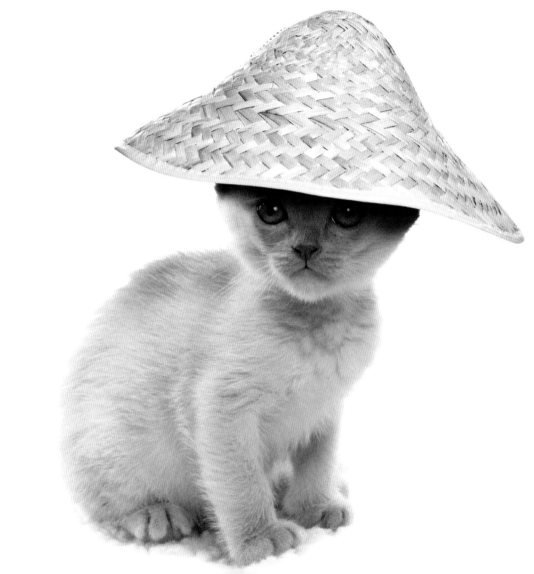

Viet Vet

"This is the hat I wear when I'm, you know, busy working in the rice fields. I don't wear it very often."

Hat Fact: The conical hat is popular across tropical Southeast Asia as protection against the sun and the rain.

Cat Fact: One of several breeds native to Thailand—formerly known as Siam—the Siamese cat is one of the most popular breeds in North America and Europe.

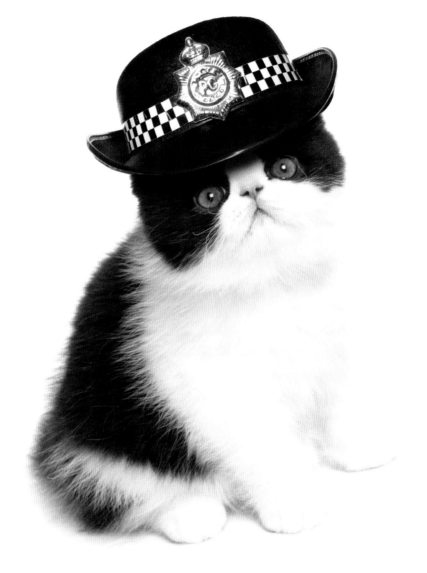

Looking for a Cat Burglar

"All right, I confess! I'm not really a policewoman, but the hat matches my colors so well."

Hat Fact: The first women police officers of London's Metropolitan Police went on patrol in 1919. This hat was introduced in 1992.

Cat Fact: Curious and playful, exotic shorthairs are friendly toward other cats and dogs. They make good apartment pets.

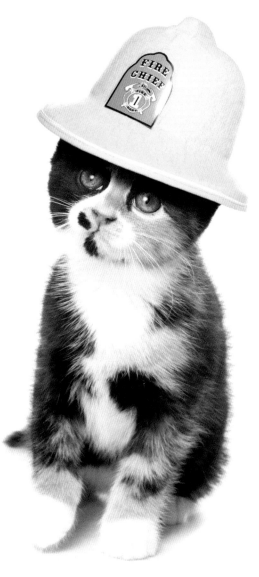

Hard-Hatted Cat

"It's a role-reversal exercise; the firefighter gets stuck up a tree, and I supervise the rescue from the ground. I think I'll leave him there a little longer."

Hat Fact: In 1919, the E.D. Bullard Company, a California mining-equipment firm, patented a "hard-boiled hat" made of steamed canvas, glue, and black paint.

Cat Fact: More than 90 percent of cats in the United States are domestic shorthairs. This isn't an actual breed, however, because their ancestry is mixed.

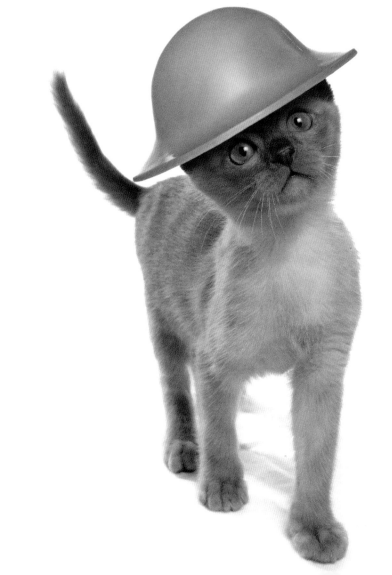

All Kitten on the Western Front

"Churchill may have been a bulldog, but I'm a tiger (almost)."

Hat Fact: Commonly known as the Tommy helmet, this steel combat helmet was patented in 1915 by Englishman John Leopold Brodie. British and U.S. soldiers used it during World War I.

Cat Fact: Originally from Southeast Asia, Burmese cats were developed in the United States and Britain. They are short-haired and stocky, and have a consistent color.

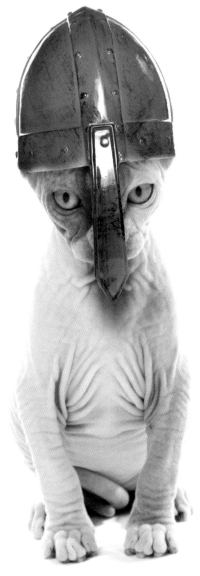

Who Stole my Hair Shirt?

"You know, I think waxing can be taken too far."

Hat Fact: A Norman helmet of the kind worn at the invasion of England in 1066.

Cat Fact: Being almost hairless, sphynxes are at risk of getting sunburned. Also, body oils, which are absorbed by the fur of other cats, can build up on sphynxes. Unsurprisingly, they don't conserve body heat well.

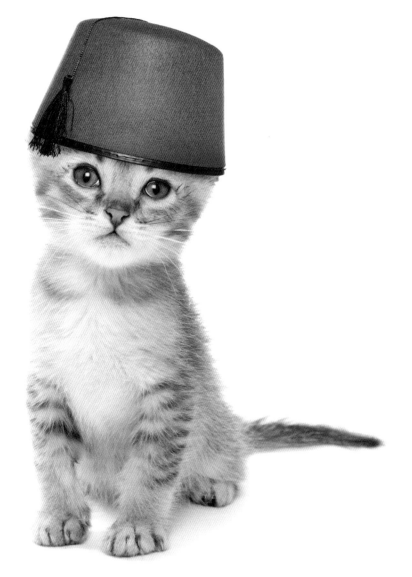

Fezzing Up

"What's a cat's favorite dessert? Mice pudding...Well, I always said my jokes were ap*paw*ling."

Hat Fact: When modernizing the Ottoman Empire's army in 1829, Sultan Mahmud II adopted Western-style uniforms. Fezzes replaced the previously worn turbans. The popularity of the fez then spread throughout the civilian population, too.

Cat Fact: Also known as Malayans, Asian cats are a breed similar to Burmese cats. They are intelligent and extroverted, enjoying and needing company.

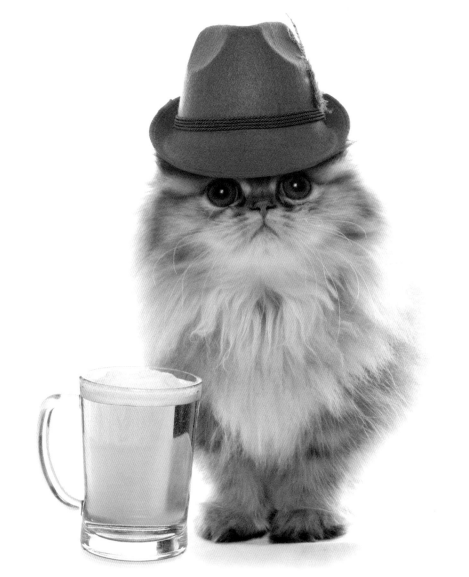

Herr Balls

"By the morning I'll be *cat*atonic."

Hat Fact: A wool felt Tyrolean hat from the Alps. The hat is worn traditionally in Austria and neighboring Bavaria in southern Germany.

Cat Fact: Breeding of Persian cats has led to the distinction of traditional Persian cats and the flatter-faced variety.

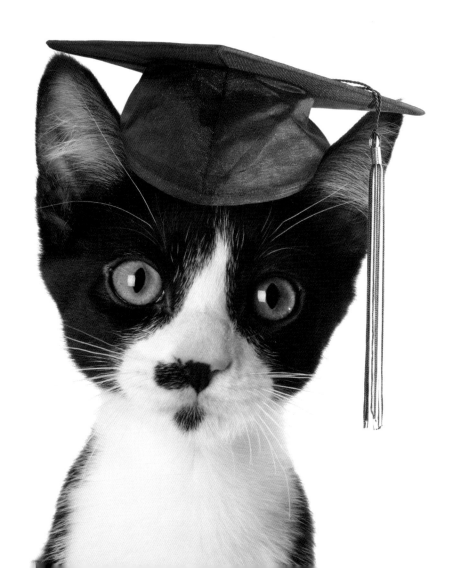

That's *Cat*ademic

"I only scraped through my pedigree by a whisker but have already been offered a post—a scratching one. Next, I hope to win the *Purr*litzer Prize, but first I'm off to a party—a Hair Ball."

Hat Fact: The square academic cap is also called a mortarboard because it resembles the board that plasterers and bricklayers use to mix mortar on.

Cat Fact: Domestic shorthairs can vary greatly in temperament because of their mixed breeding.

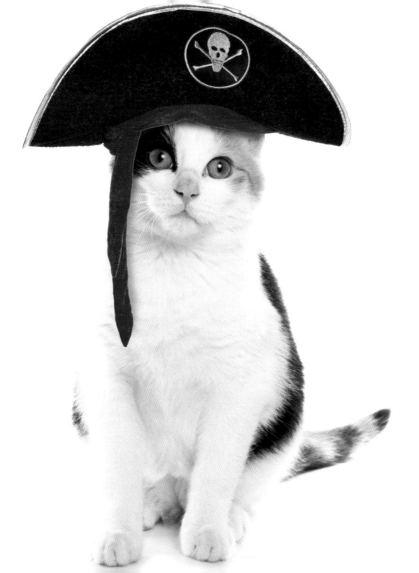

The Cat-o'-Nine Tails

"I make a good pirate; I have the hat and my right eye has a black mark like a patch. But I just can't tempt a parrot to sit on my shoulder."

Hat Fact: We may associate the bicorne hat with Napoleon Bonaparte, but it was worn by most American and European army and naval officers from the 1790s to 1914.

Cat Fact: As a mixed breed, domestic shorthairs have a wide gene pool and consequently are more robust and less vulnerable to genetic problems than purebred cats.

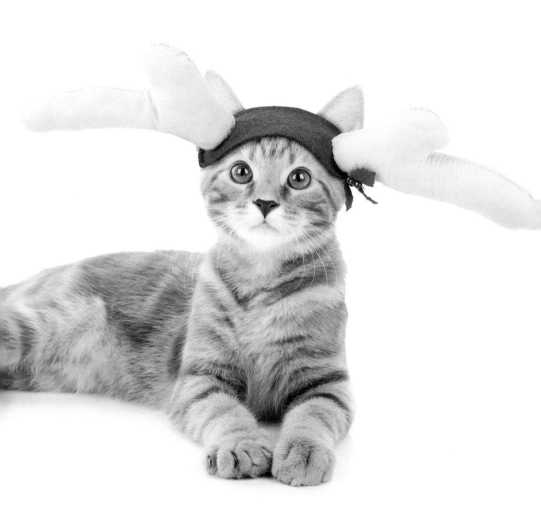

Have Fur, Will Fly

"Look, it's all part of the Christmas spirit. You gotta believe—in Santa, in the flying sleigh, and in me as a reindeer."

Hat Fact: Like Santa's elves, reindeer became associated with Christmas largely because of Clement Clarke Moore's 1823 poem "Twas the Night Before Christmas."

Cat Fact: The domestic shorthair, as seen here, and the American shorthair were classified as the same breed until 1966, when the American shorthair was classified as a breed of its own.

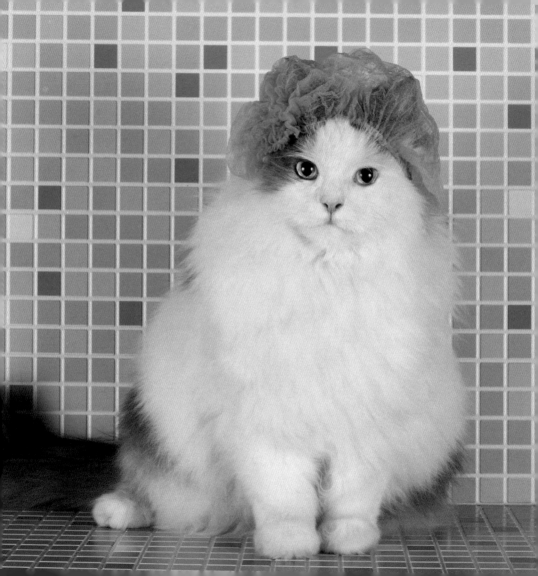

Shower Cat

"I never thought I'd envy those hairless cats."

Hat Fact: A shower cap isn't necessary for your cat. Most cats look after their own grooming. If your cat gets so dirty that it can't clean itself, then you will have to bathe it.

Cat Fact: Domestic longhairs are cats of mixed ancestry and not one particular breed. They can have fur up to six inches long.

63

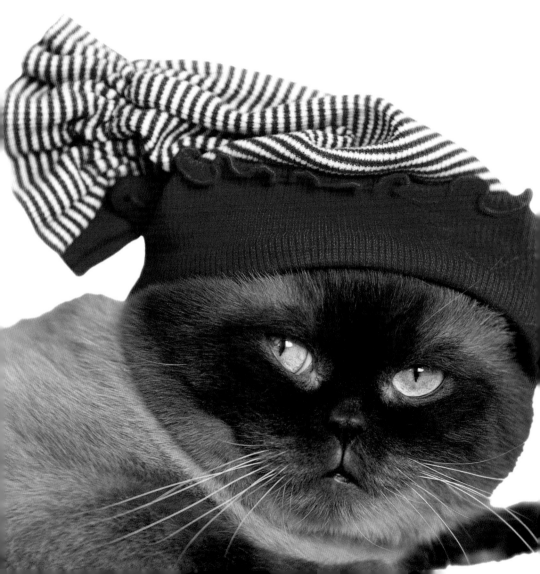

The Cat's Pyjamas

"When they said that they were bringing me a nightcap, I imagined a whisker sour or at least a glass of warm milk."

Hat Fact: Nightcaps were long so they could also act as a scarf, helping the sleeper stay warm through the night.

Cat Fact: In Thailand, Siamese cats are called "Moon diamond" cats.

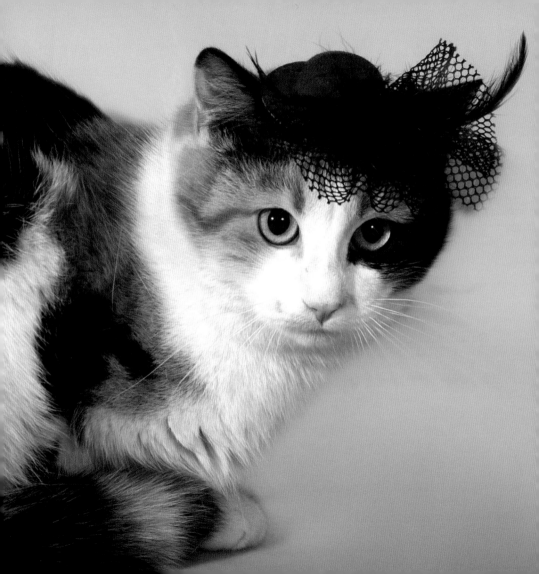

Bride or Grooming?

"The fascinator was expensive, but at least the fur is free."

Hat Fact: Since the 1990s, fascinators have become popular as alternatives to hats at formal events, such as weddings, though they are not permitted in the Royal Enclosure at the Royal Ascot horse-racing events.

Cat Fact: Domestic longhairs are also known as "long-haired house cats" and, in British English, "long-haired moggies."

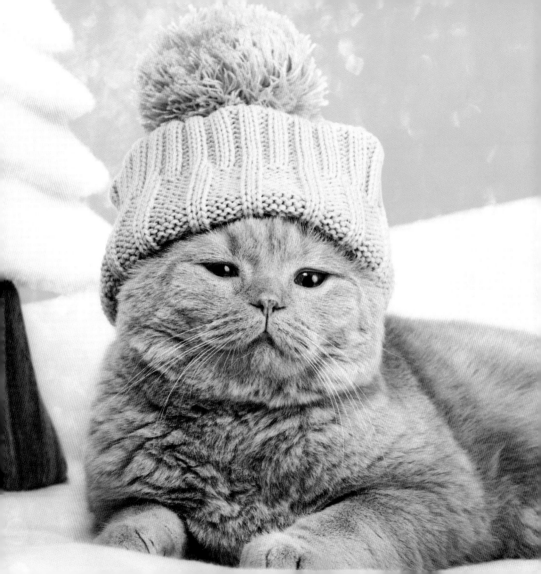

Much Too Cool for Cats

"To be perfectly honest, I'm feline rather cold."

Hat Fact: Mike Nesmith wore a bobble hat to his audition for the 1960s TV show *The Monkees*. The producers remembered the hat. When they cast him, they had him wear it in every episode.

Cat Fact: A red British shorthair. It's thought that the British shorthair's origins date back to the first century CE, when the Romans brought Egyptian domestic cats to Britain, and these interbred with European wildcats.

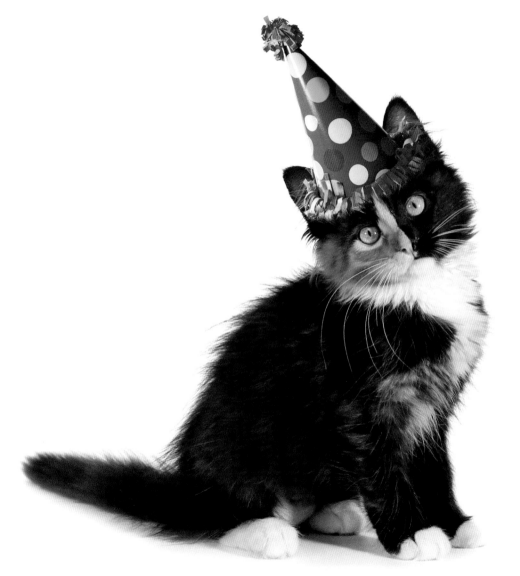

Tabby the Magnifi*cat*

"You can tell I'm a real party animal... Actually, I quite like the yo-yo."

Hat Fact: Pointed hats are also worn in the rural Louisiana Mardi Gras celebrations.

Cat Fact: Domestic longhaireds have ear tufts and toe tufts.

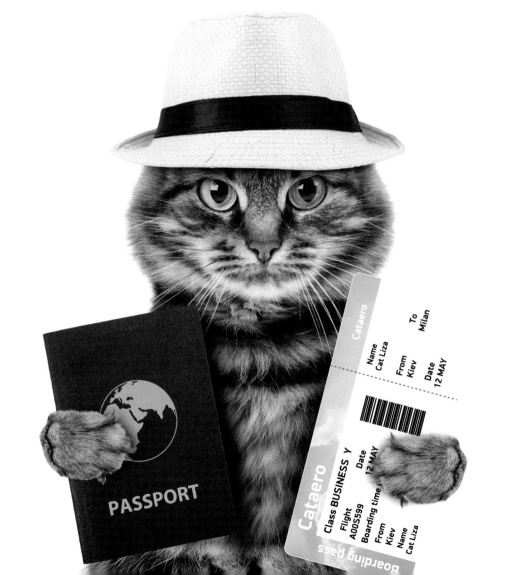

PASSPORT

Cataero

Name
Cat Liza

To
Milan

From
Kiev

Date
12 MAY

Cataero

Class BUSINESS Y Date
 12 MAY

Flight
A00S599

Boarding time

From
Kiev

Name
Cat Liza

Boarding pass

Domesti*cat*ed Flight

"With air travel, I always insist on a seat near the tail, but there's still one thing that scares me—landing on water."

Hat Fact: To be asked which country the panama hat is from might seem obvious. However, in fact, it isn't from Panama but Ecuador. Although originally made in Ecuador, the straw hats became more broadly known as panamas when they were traded out through that country.

Cat Fact: Although they are not bred as show cats, domestic shorthairs can be entered into cat shows that have non-purebred "Household Pet" divisions.

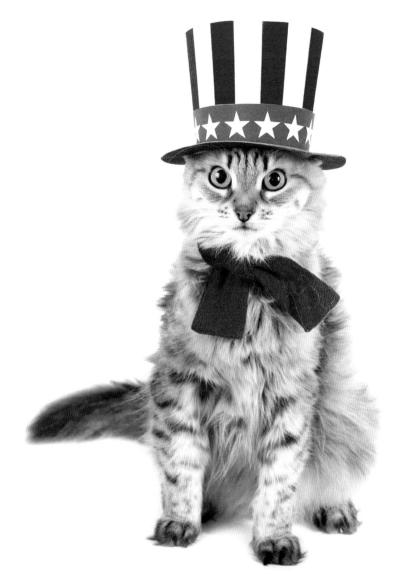

Demo*cat* or Republi*cat*?

Throwing your cat in the political ring is a risky business in this dog-eat-dog world.

Hat Fact: The character of Uncle Sam was first used during the War of 1812 between the United States and Great Britain.

Cat Fact: The American curl is noted for its ears, which curl back from the face. In this image, they're hidden by the Uncle Sam hat.

75

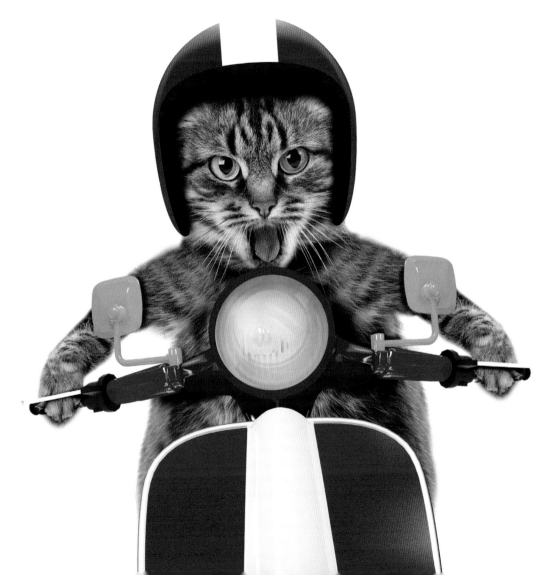

Gasoline Alley Cat

"No, I don't know how to drive this. Good thing I've got nine lives."

Hat Fact: One of the first rules insisting that motorcyclists wear crash helmets was introduced in Britain at the Isle of Man TT (Tourist Trophy) races in 1914.

Cat Fact: On average, a domestic shorthair that explores outside the home will spend up to six hours a day just hunting.

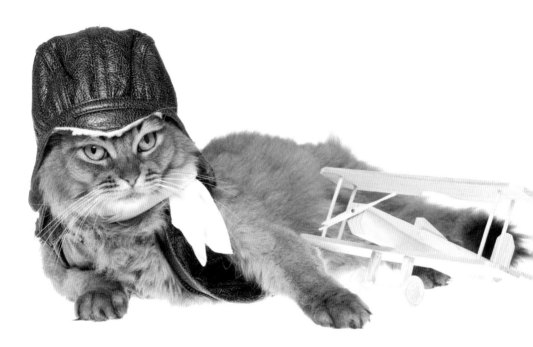

In a Tailspin

"Leaving for Kathmandu, Ne*paw*l."

Hat Fact: In 1909, the look of the aviator flying cap was born when Louis Blériot wore a soft, leather flying helmet and goggles for his flight across the English Channel.

Cat Fact: Somali cats first appeared as long-haired kittens in litters of Abyssinian cats. They are most often ruddy but can also appear red, blue, or fawn.

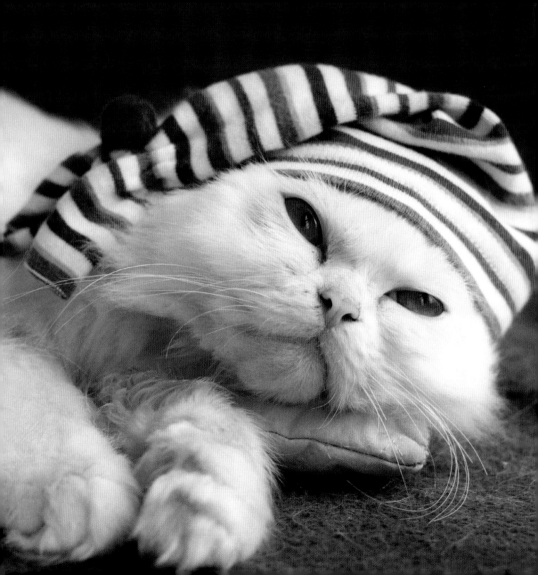

Thinking Cat

"The truth is, I sleep better with this on."

Hat Fact: In British prisons until 1850, the hood that hid a prisoner's final moments when he or she was being hanged was their nightcap. After they said their final prayers, the cap was pulled down over their face before the execution began.

Cat Fact: The Persian cat is an older breed. They are characterized by their placid temperament, long hair, short muzzle, and round face.

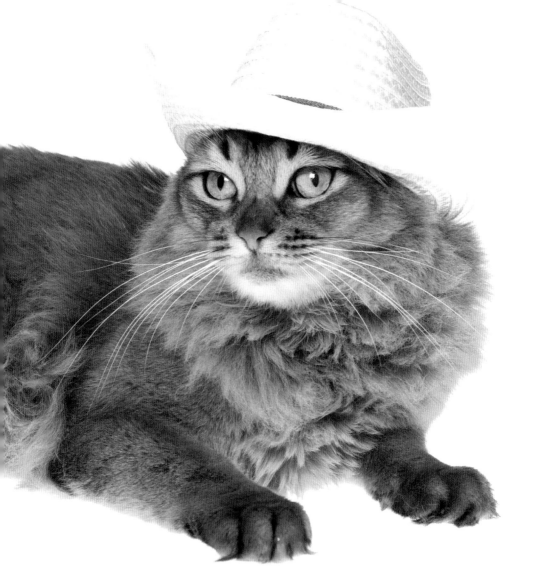

The Good, the Bad, and the Furry

"Now, he may have a six-shooter, but I've got nine lives."

Hat Fact: John B. Stetson created a hat for himself from thick beaver felt while panning for gold in Colorado. In 1865, he returned East and, joining the family trade, began manufacturing his "Boss of the Plains" cowboy hat.

Cat Fact: The Somali's large, almond-shaped eyes range in color from green to copper.

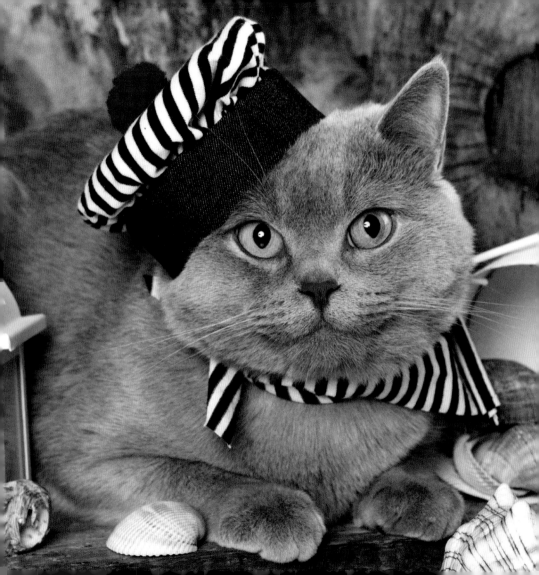

I Only Sail by *Cat*amaran

"To be honest, I'm still struggling to get my sea paws and have been as sick as ...well, as a cat."

Hat Fact: A Bachi, a French sailor's bonnet. Unlike other sailor caps, the Bachi is topped with a red pompom.

Cat Fact: A British blue shorthair. The British shorthair was the inspiration for John Tenniel's original illustration of the Cheshire Cat in *Alice's Adventures in Wonderland*.

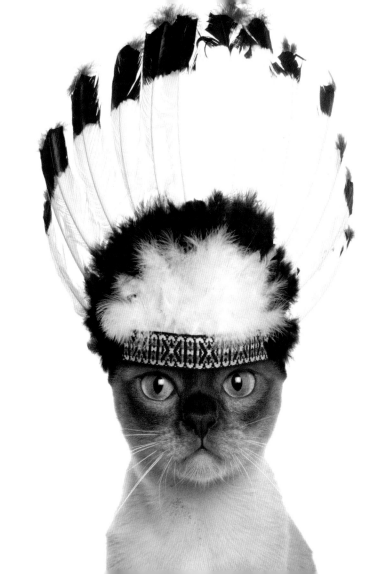

The *Paw*hatan Confederacy

"When you said you had a feathered gift for me, I was expecting, you know, a bird."

Hat Fact: War bonnets are traditionally worn only by highly respected male members of Plains Indians tribes.

Cat Fact: Burmese cats originally all had dark brown coats (known as sable), but they are now available in a wide variety of colors, including blue, red, cream, tortoiseshell, champagne, and platinum.

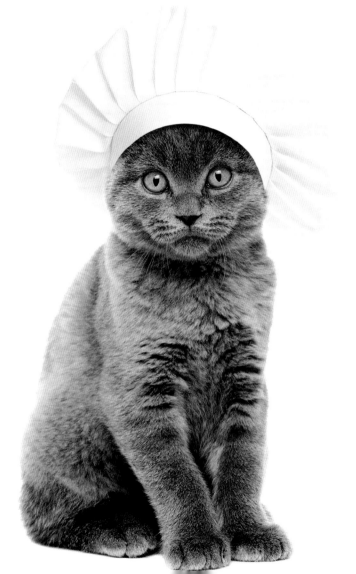

Mice Pudding

"If I said I was an excellent chef, would you think I was talking out of my hat?"

Hat Fact: The tall, pleated style of the modern chef's toque hat originated in France in the 19th century.

Cat Fact: The Chartreux is a rare French breed that looks like a British shorthair. Large and muscular, with short, fine bones, the Chartreux is noted for its blue-gray double coat.

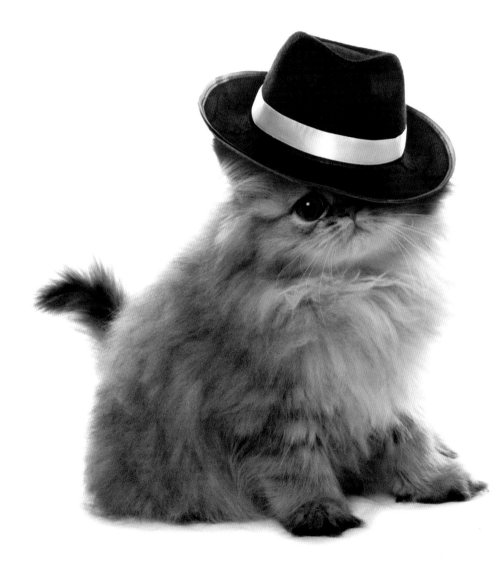

Keep It Under Your Hat

"Do I look cool or just partially sighted? You decide.

Hat Fact: The name of the Fedora hat comes from Victorien Sardou's play *Fédora*. When Sarah Bernhardt first performed the play in the United States in 1889, she wore a center-creased, soft-brimmed hat, popularizing the name and also the look.

Cat Fact: A Persian cat was presented at the first organized cat show in 1871 at Crystal Palace in London.

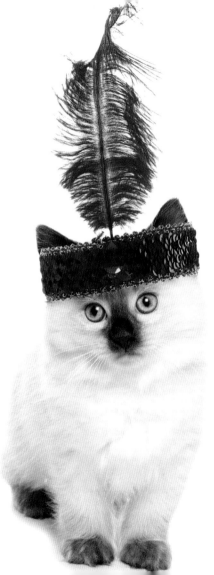

Glamourpuss

"I know, I know—where are my kitten heels?"

Hat Fact: A flapper headband. Besides headbands, flappers often wore cloche hats and were noted for their bob haircuts.

Cat Fact: The Birman, also called the "sacred cat of Burma," takes its name from *Birmanie*, the French word for the country Burma. They have no undercoat and are less prone to matting.

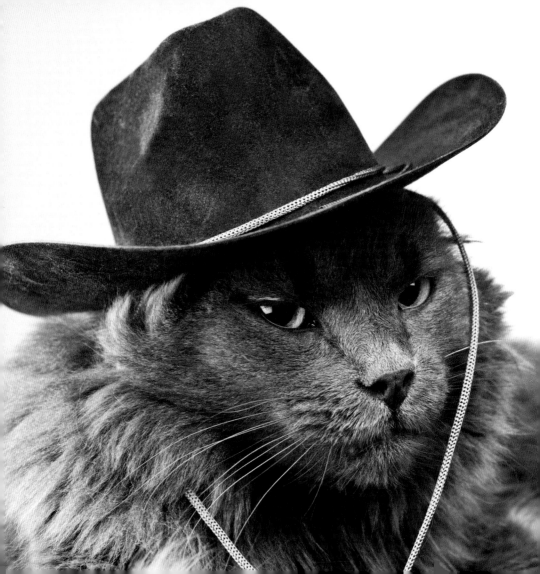

The Catty Kid

"Cattle rustling ain't so hard when you've herded as many cats as I have."

Hat Fact: Cowboy hats, adopted from the Mexican vaqueros, were popular among cowboys in the West, though people moving West wore all kinds of hats.

Cat Fact: One of the largest domesticated breeds, the Maine coon is also one of the most popular breeds in the world. They have a thick, flowing coat, a large frame, and a bushy tail.

THE

END